"DOGS BELIEVE THEY ARE HUMAN. CATS BELIEVE THEY ARE GOD."

T0148651

JEFF VALDEZ

INSTA GRAMMAR
JUST CATS

𝕃 | LANNOO

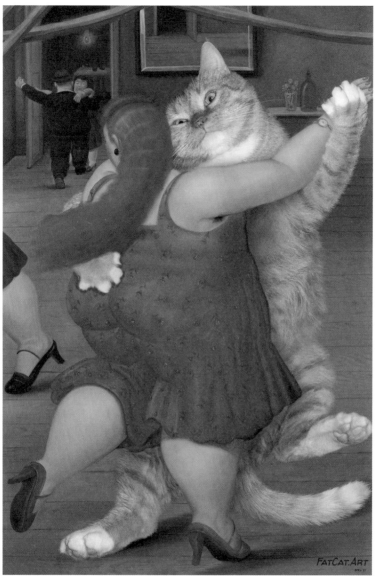

@FATCATART

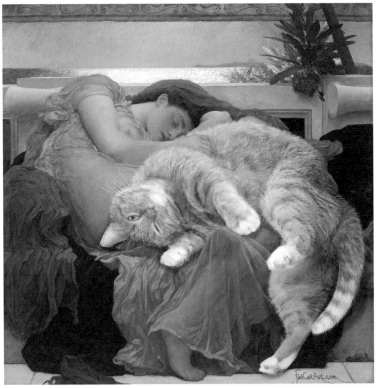

@FATCATART

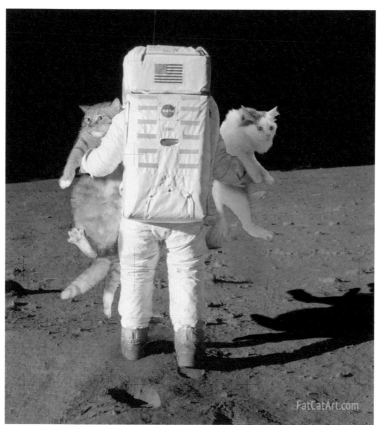

FatCatArt.com

@FATCATART

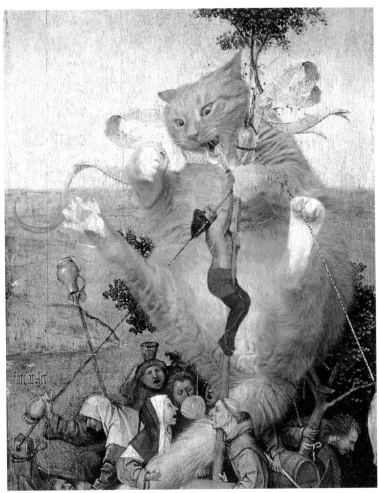

FatCatArt

@FATCATART

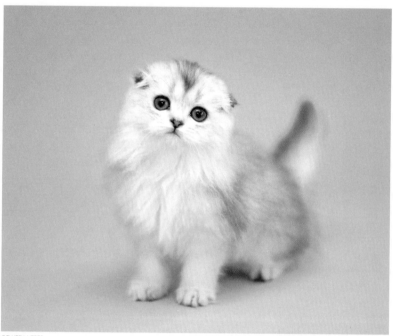

@FLUFFY_NERFS

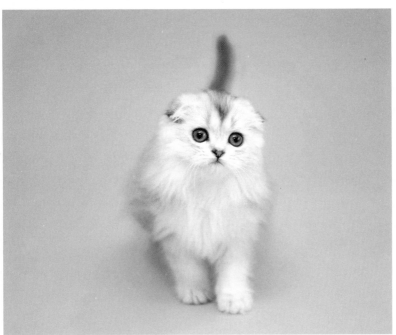

@FLUFFY_NERFS

"IT IS IMPOSSIBLE TO KEEP A STRAIGHT FACE IN THE PRESENCE OF ONE OR MORE KITTENS."

CYNTHIA E. VARNADO

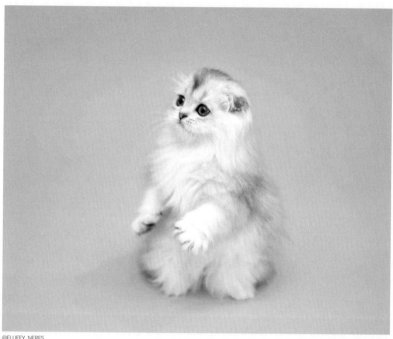

@FLUFFY_NERFS

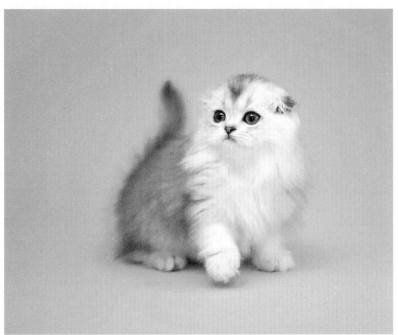

@FLUFFY_NERFS

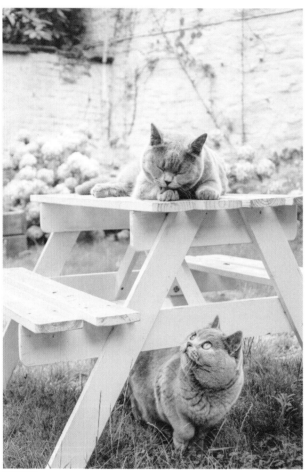

@KARLIJNEG

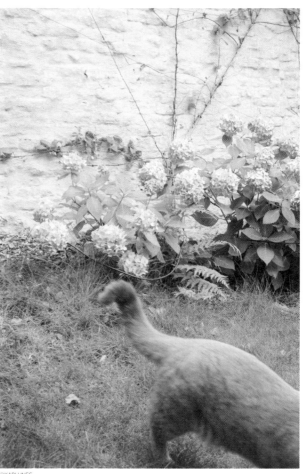

@KARLIJNEG

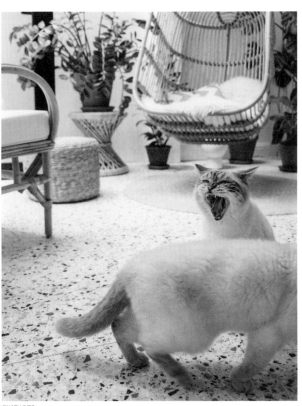

@KARLIJNEG

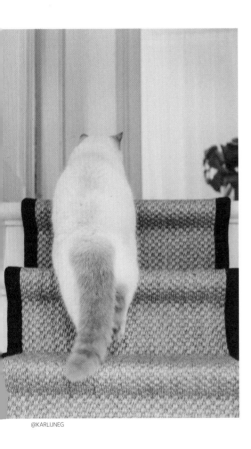

@KARLUNEG

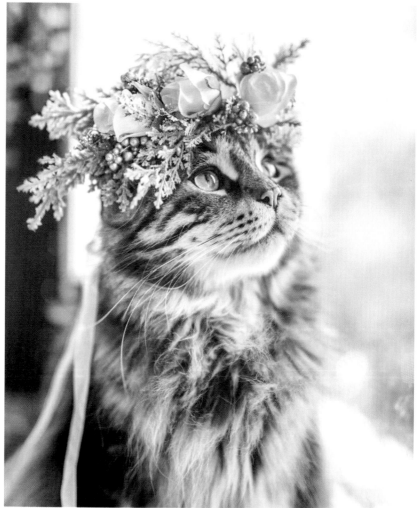

@LEO.MAINECOON

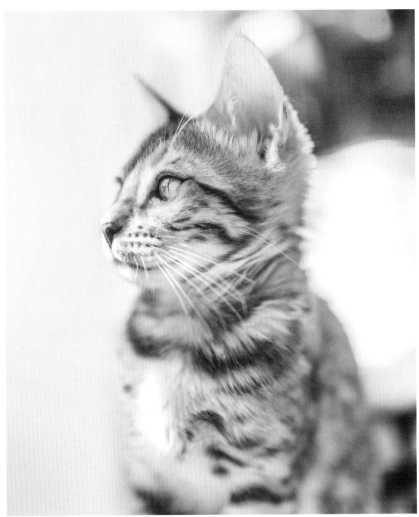

@LEO.MAINECOON

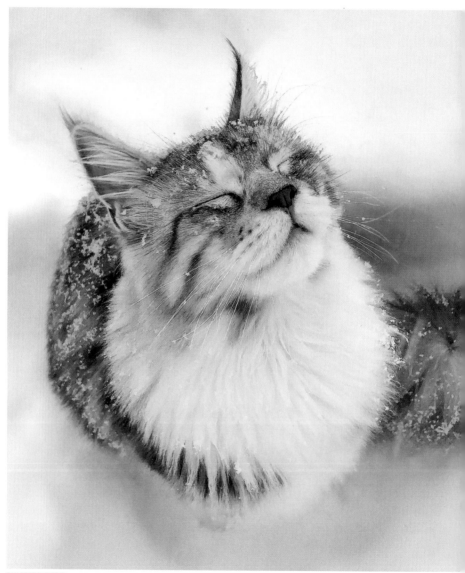

@MAINECOONQUEENS

"IF CATS COULD TALK, THEY WOULDN'T."

NAN PORTER

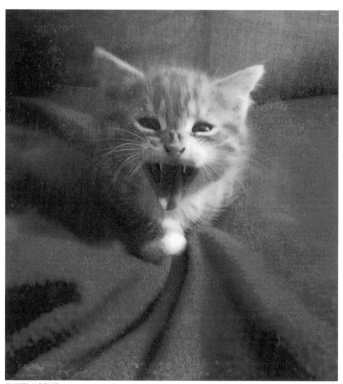

@HAMZA_H_DJENAT

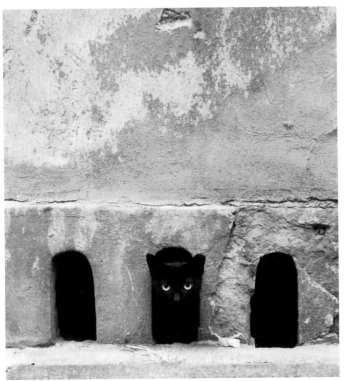
@HAMZA_H_DJENAT

@METATRONEYES_MAINE_COONS

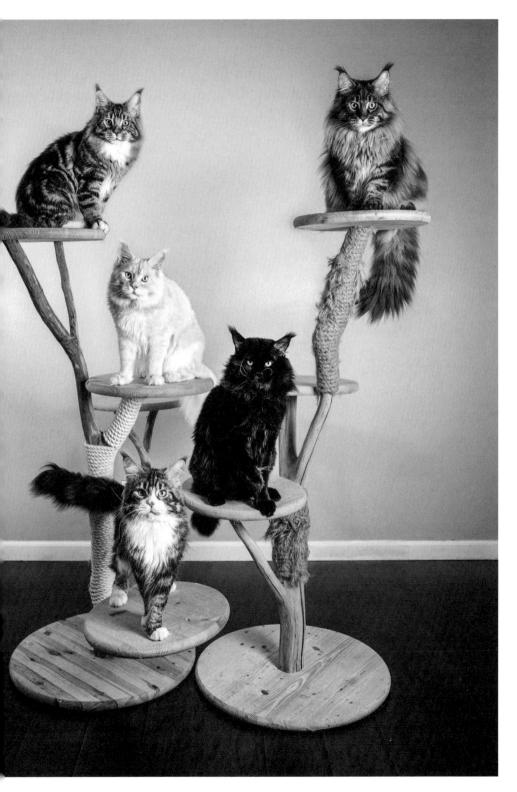

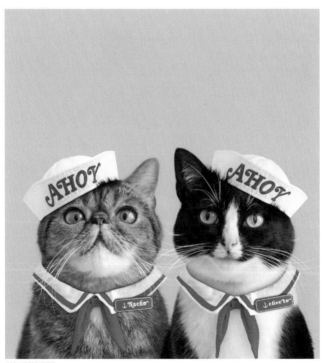

@PRINCESSCHEETO

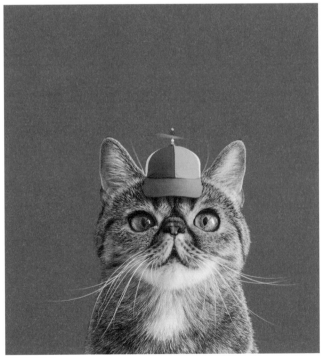

@PRINCESSCHEETO

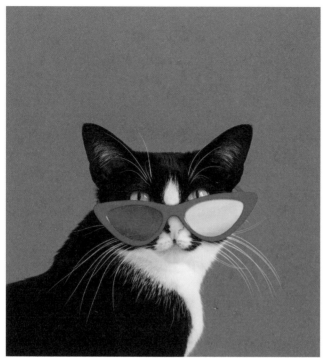

@PRINCESSCHEETO

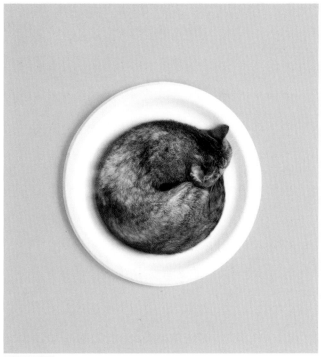

@PRINCESSCHEETO

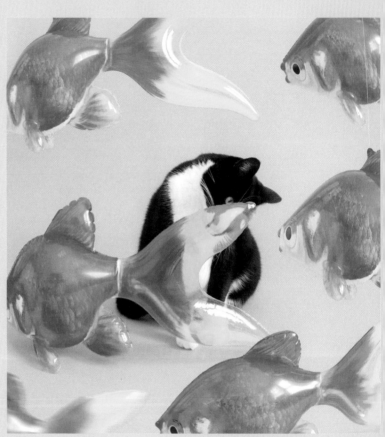

@PRINCESSCHEETO

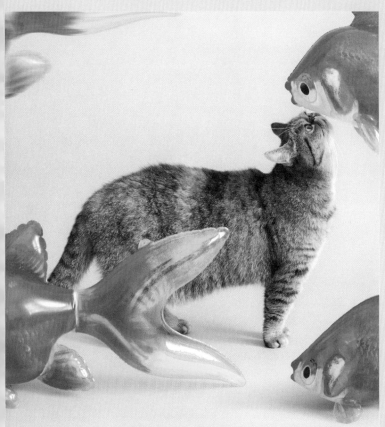

@PRINCESSCHEETO

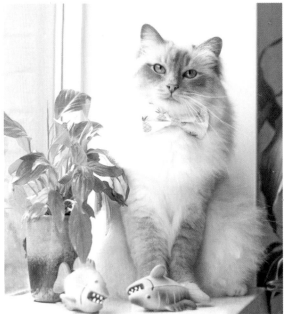

@THEBIRMANTWINS

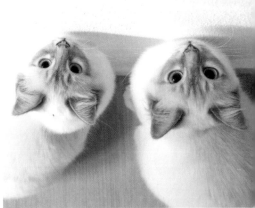

@THEBIRMANTWINS

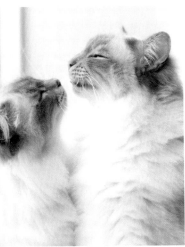

@THEBIRMANTWINS

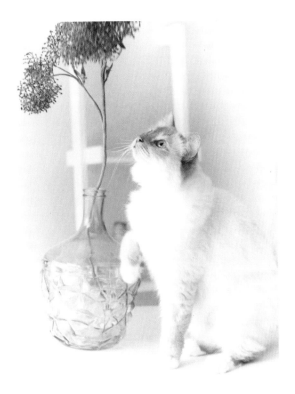

@THEBIRMANTWINS

"CATS HAVE IT ALL. ADMIRATION, AN ENDLESS SLEEP, AND COMPANY ONLY WHEN THEY WANT IT. "

ROD MCKUEN

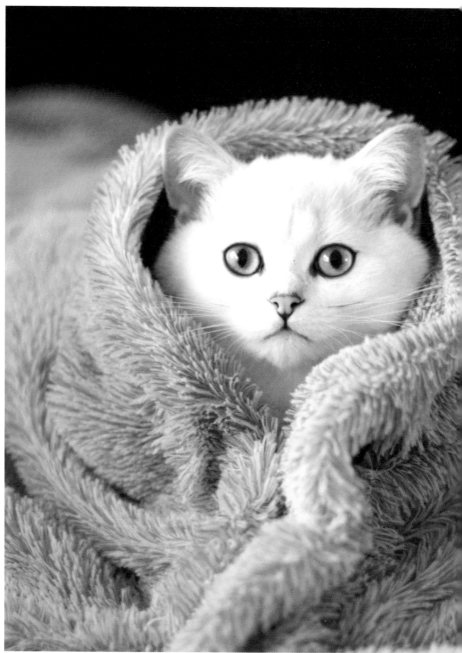

@THIS_IS_AICO

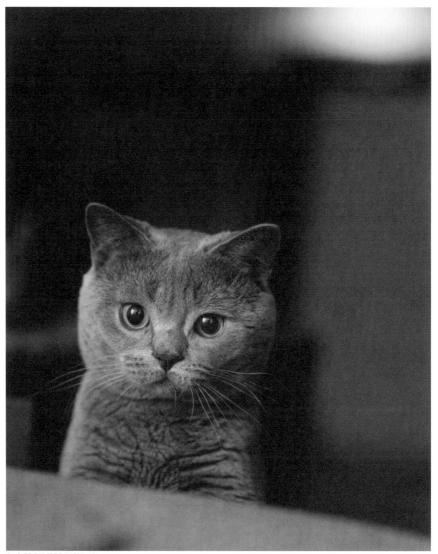

@WOLFIE_THE_BRITISHSHORTHAIR

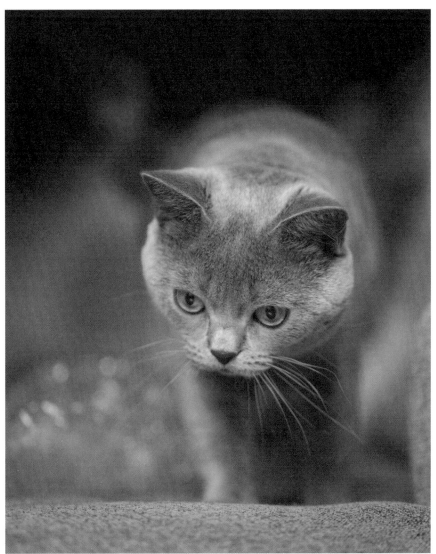

@WOLFIE_THE_BRITISHSHORTHAIR

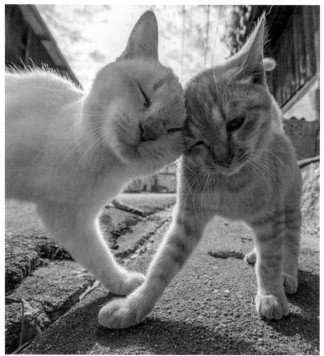
@EVERYTHING_ABOUTCATS_

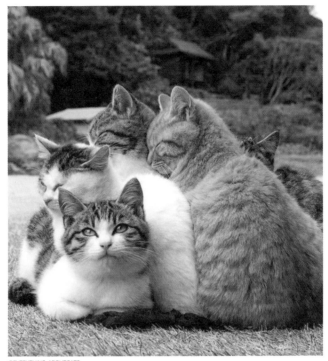

@EVERYTHING_ABOUTCATS_

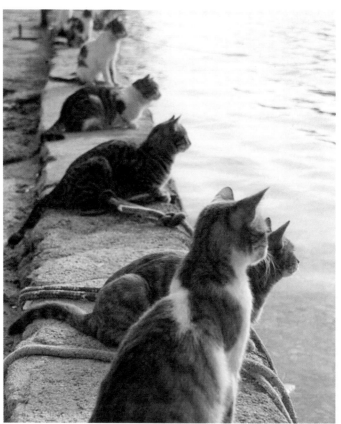

@EVERYTHING_ABOUTCATS_

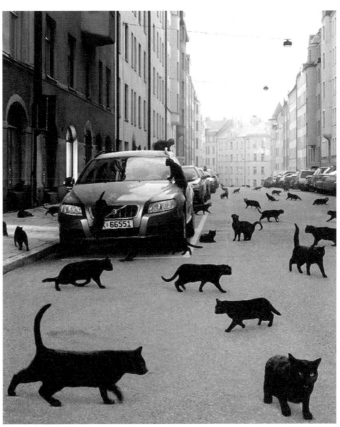

@EVERYTHING_ABOUTCATS_

@LYO.THECAT

@LYO.THECAT

@LITTLELORDREGINALD

@LITTLELORDREGINALD

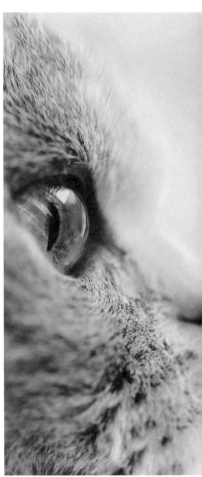
@LYO.THECAT

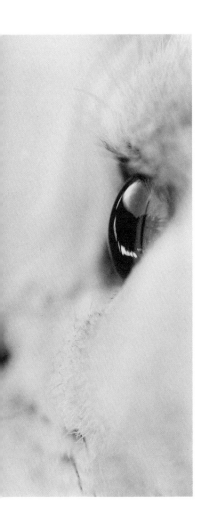

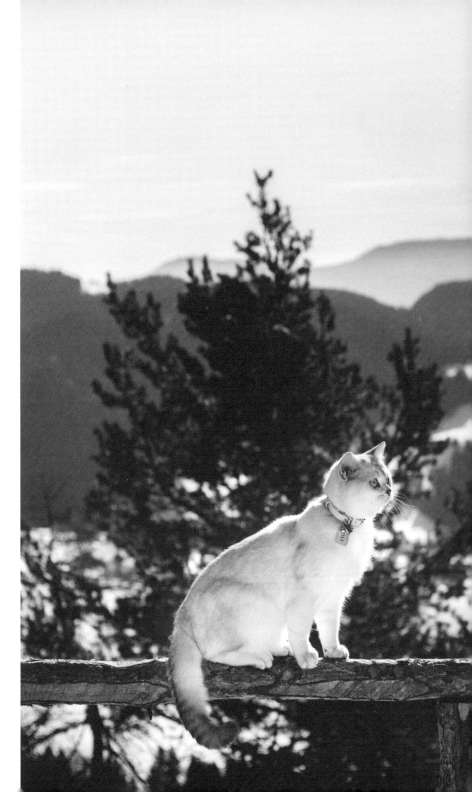

@LYO.THECAT

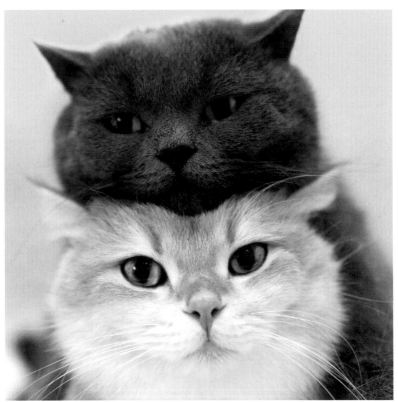

@AMY_SIMBA

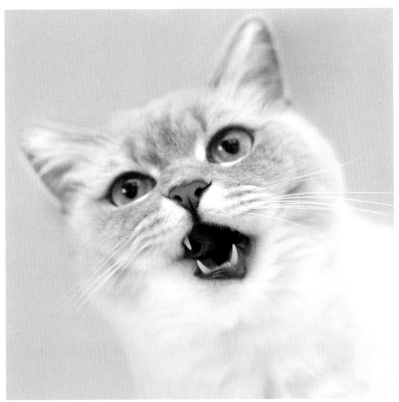

@AMY_SIMBA

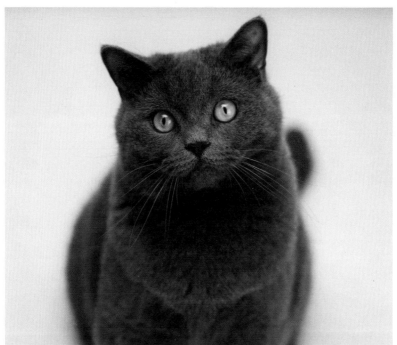

@AMY_SIMBA

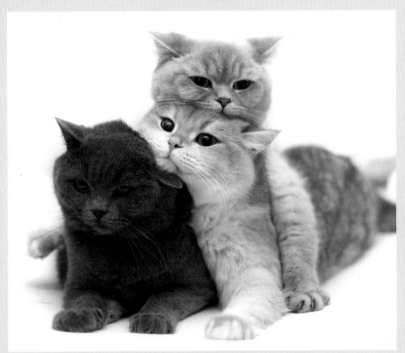

@AMY_SIMBA

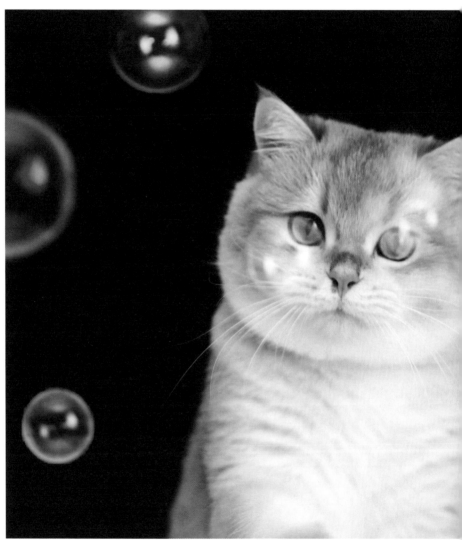

@AMY_SIMBA

"IT ALWAYS GIVES ME A SHIVER WHEN I SEE A CAT SEEING WHAT I CAN'T SEE."

ELEANOR FARJEON

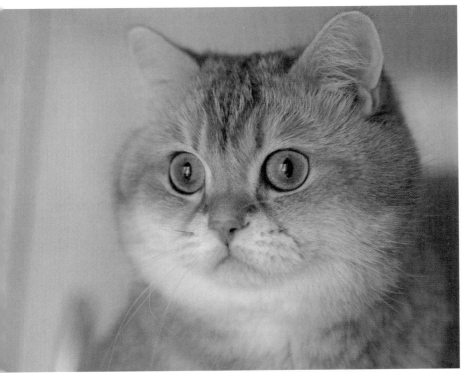

@HOSICO_CAT

@HOSICO_CAT

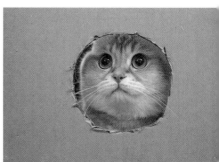

@HOSICO_CAT

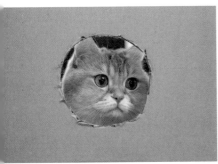

HOSICO_CAT

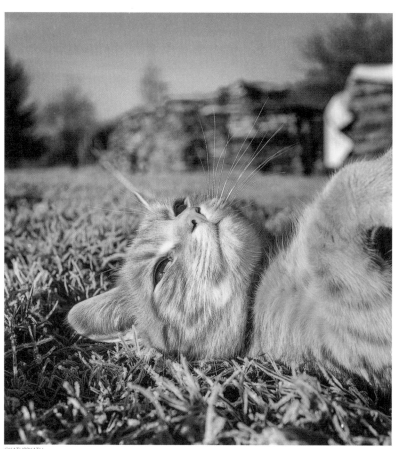

@KATH88KATH

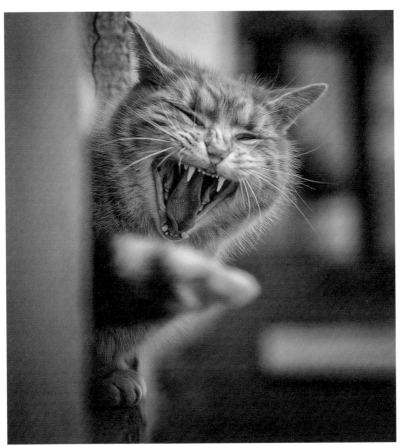

@KATH88KATH

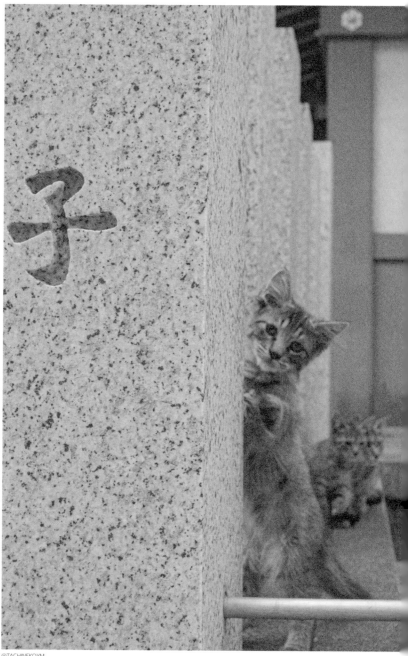

@TACHINEKO.YM

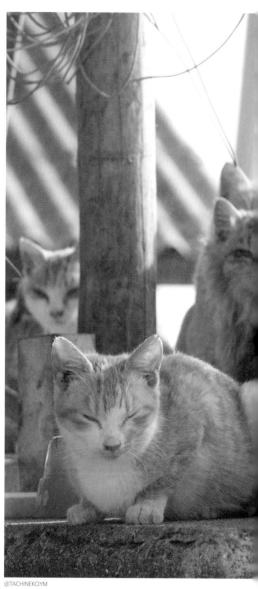

@TACHINEKO.YM

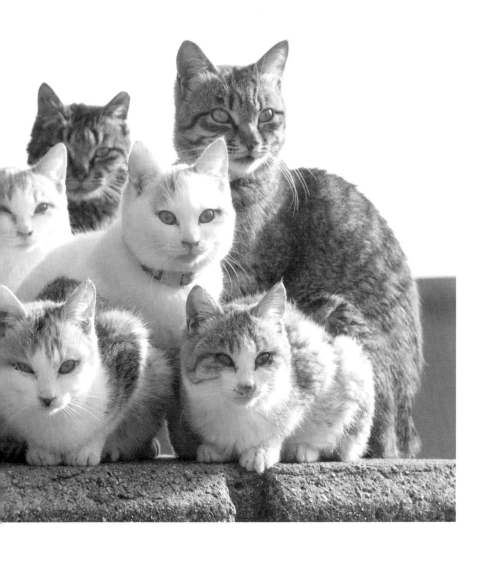

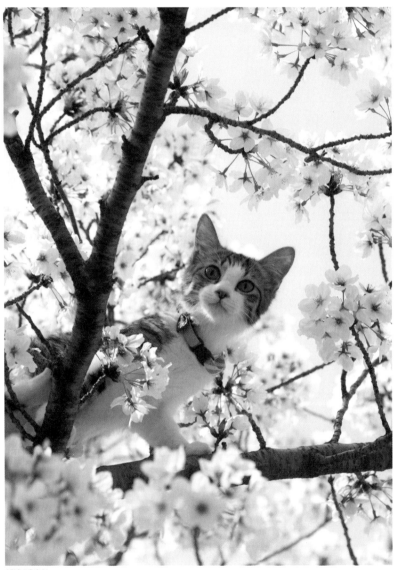

@TACHINEKO.YM

"SOMETIMES THEY JUST APPEAR IN YOUR LIFE, CATS."

RON CURRIE JR

@TACHINEKOYM

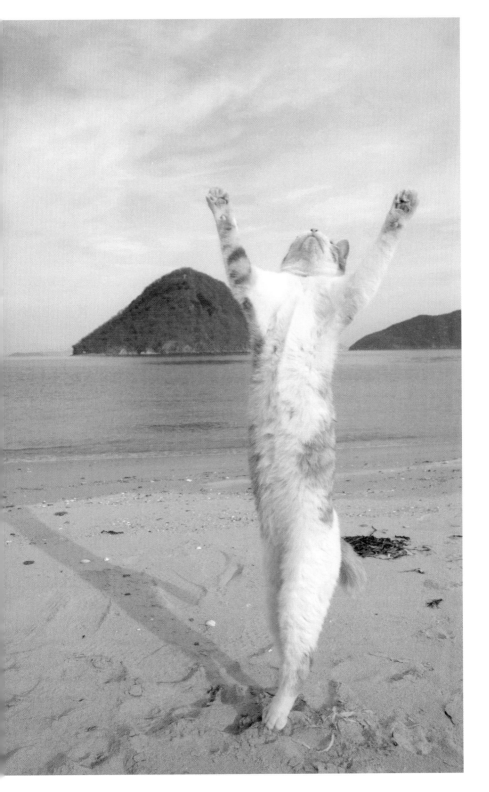

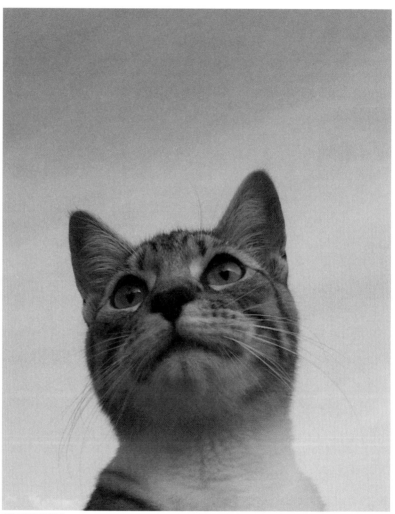

@GUNBATIMINDAKIMOR

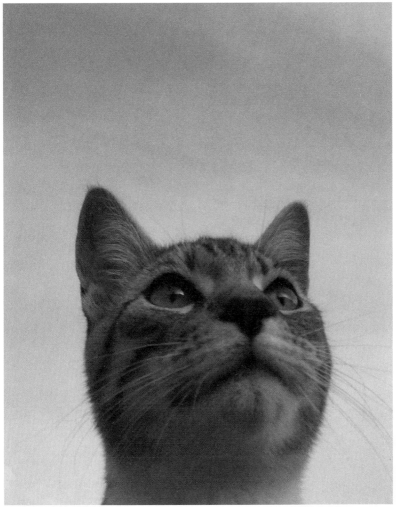

@GUNBATIMINDAKIMOR

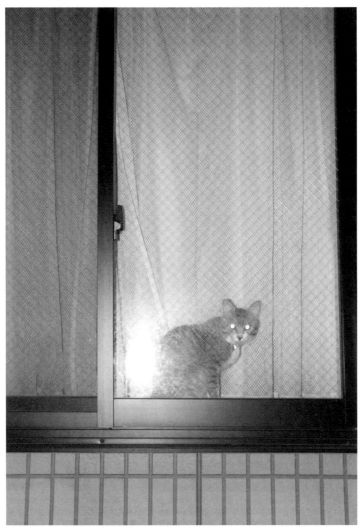

@YOSHINORI_MIZUTANI

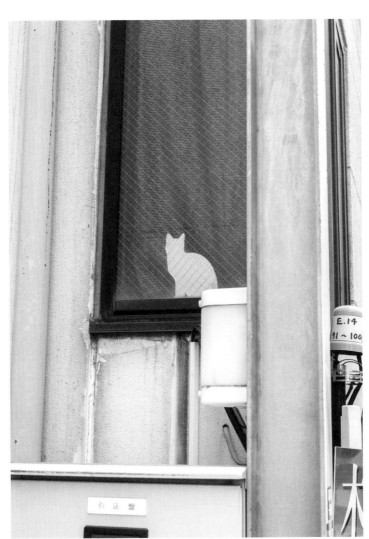

@YOSHINORI_MIZUTANI

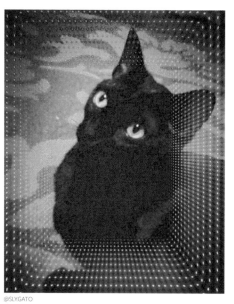

@SLY.GATO

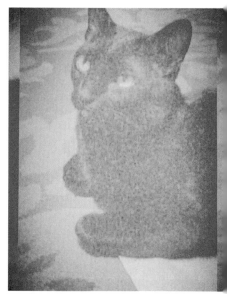

@SLY.GATO

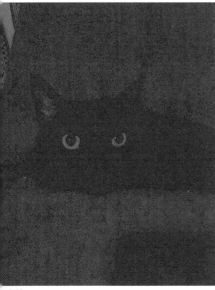

LYGATO

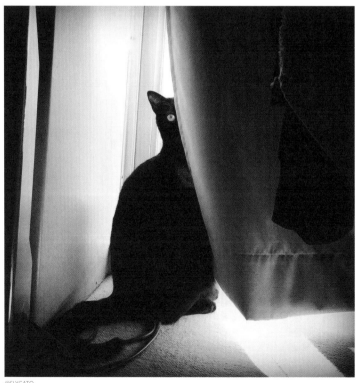

@SLYGATO

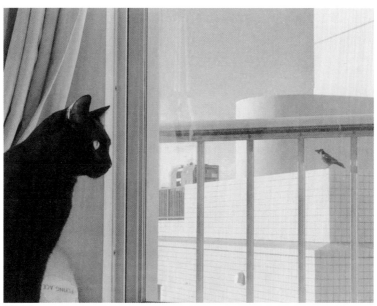

@SLYGATO

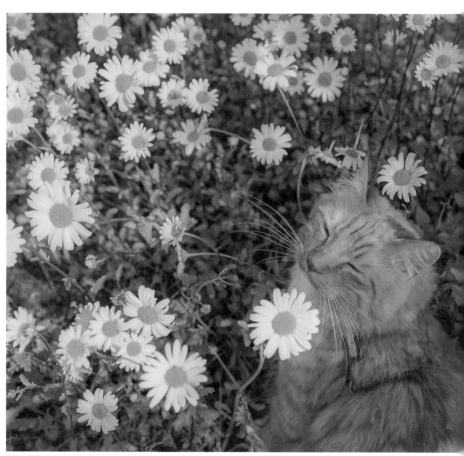

@PRIMUSCAT

"MY CAT IS NOT INSANE, SHE'S JUST A REALLY GOOD ACTRESS."

P.C. CAST

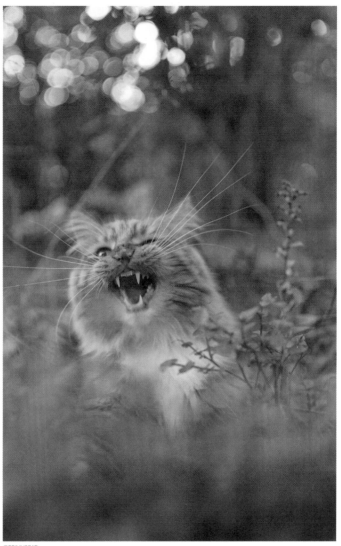

@PRIMUSCAT

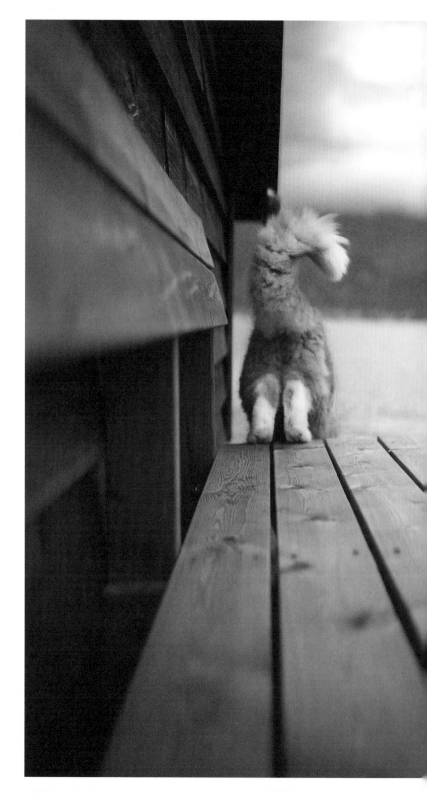

@PRIMUSCAT

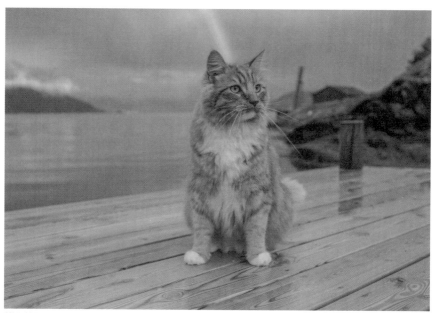

@PRIMUSCAT

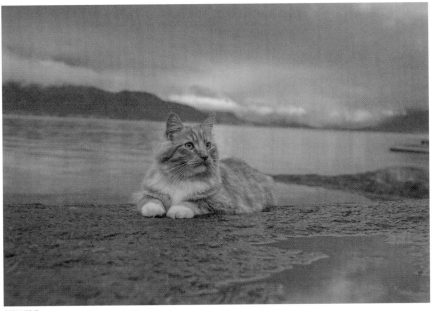

@PRIMUSCAT

@SKYCATTERY

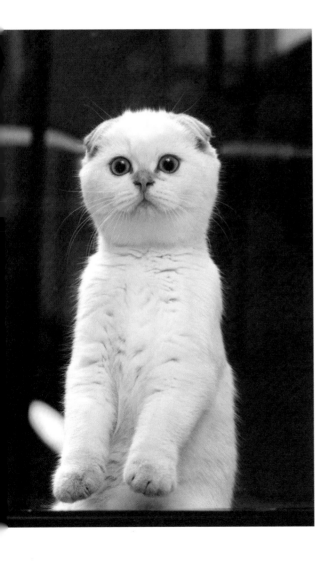

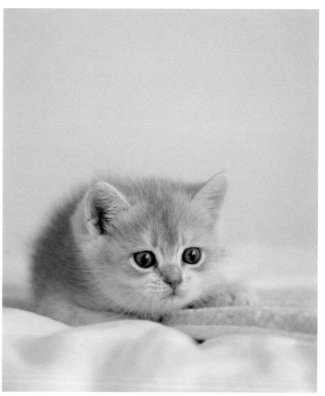

@SKYCATTERY

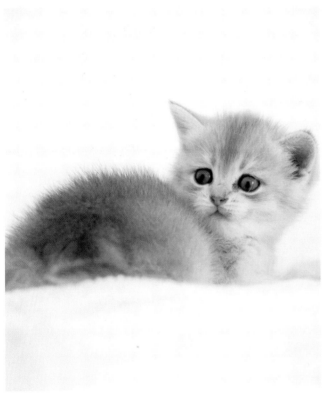

@SKYCATTERY

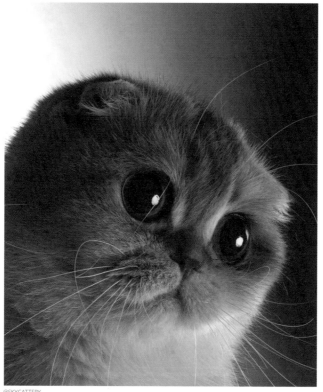

@SKY.CATTERY

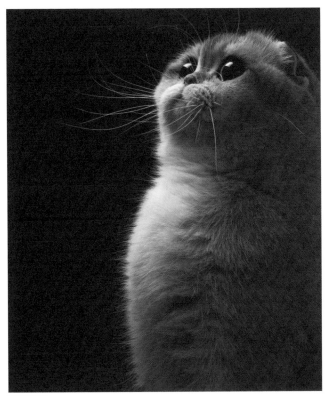

@SKYCATTERY

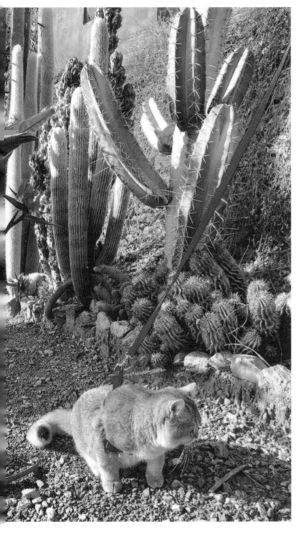

@THESEY_CAT

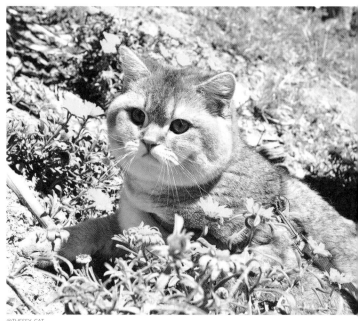
@THESEY_CAT

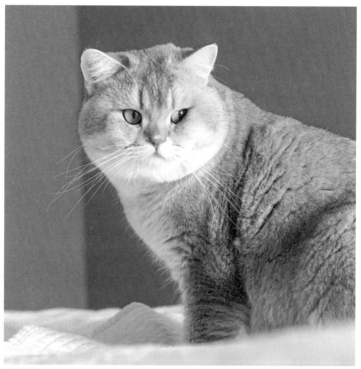

@THESEY_CAT

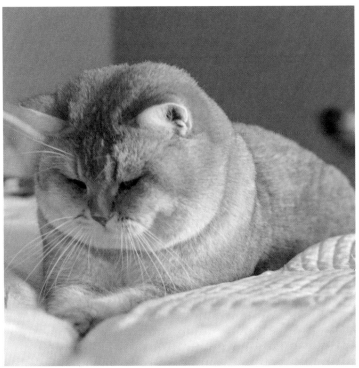

@THESEY_CAT

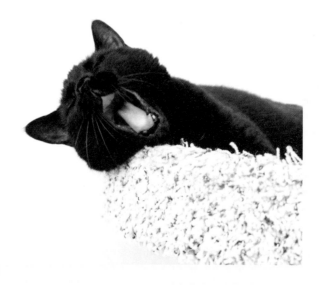

@EVERYDAY_OLIVE

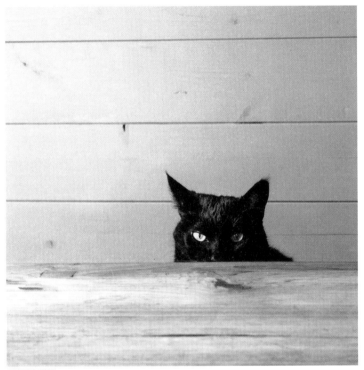

@EVERYDAY_OLIVE

@KUROTOINU

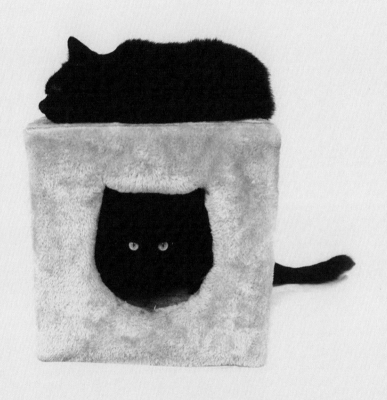

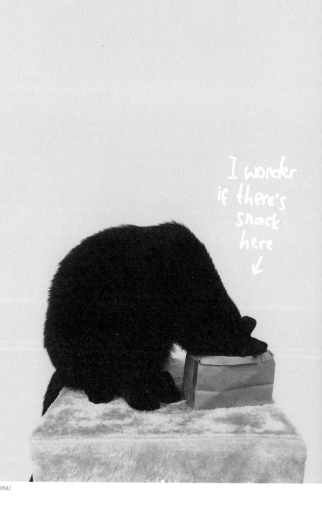

I wonder if there's snack here ↙

@KUROTOINU

@KUROTOINU

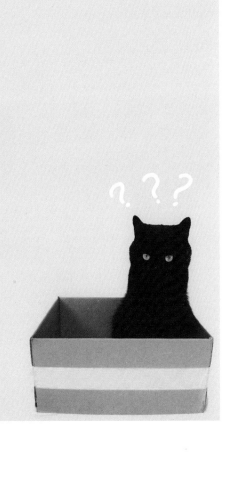

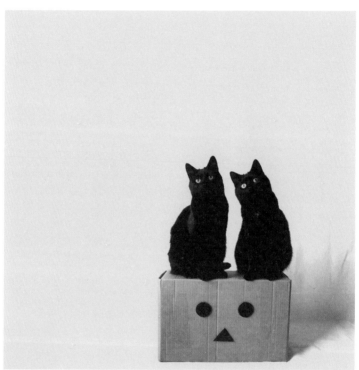

@KUROTOINU

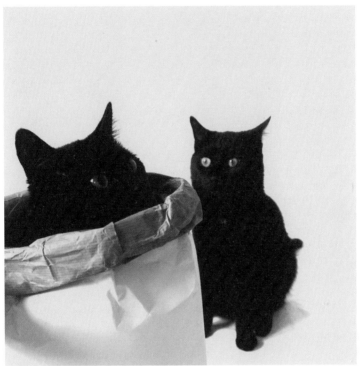

@KUROTOINU

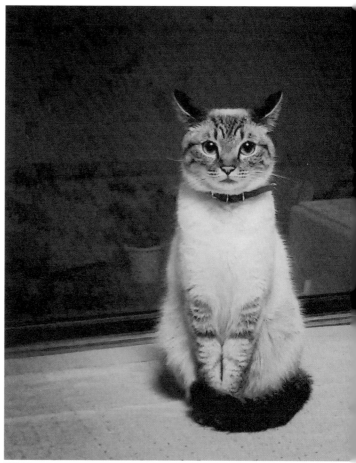

@NYAJ1100

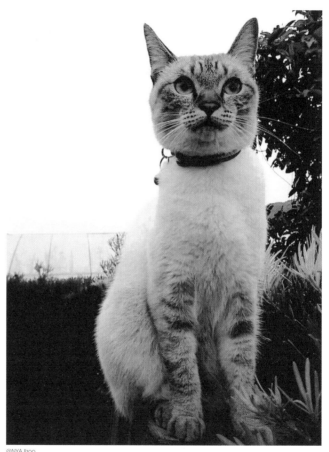

@NYAJI100

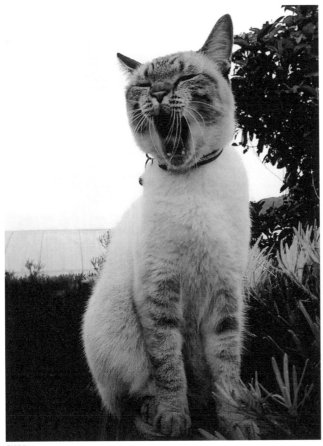

@NYAJhoo

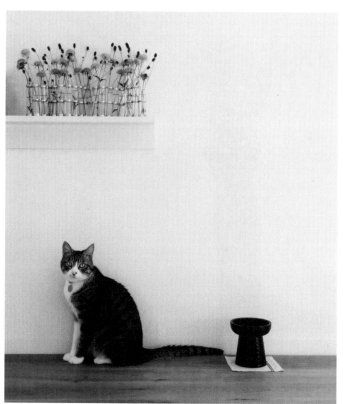

@ROLLO_SHOEGAZER

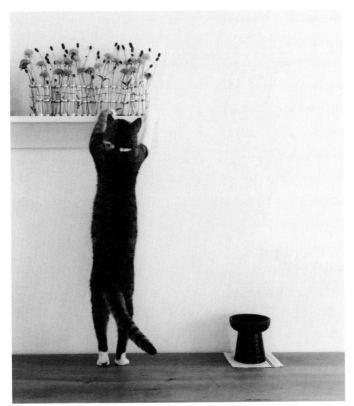

@ROLLO_SHOEGAZER

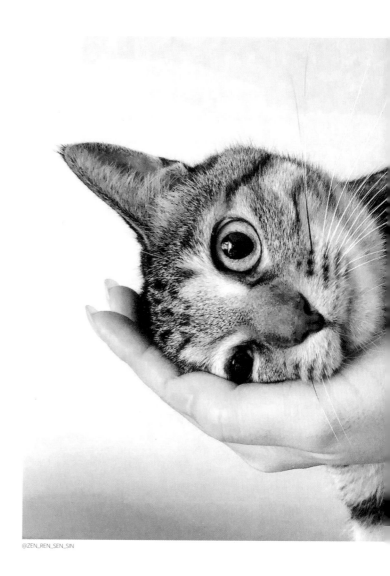

@ZEN_REN_SEN_SIN

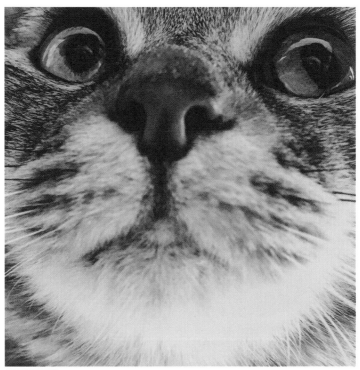

@ZEN_REN_SEN_SIN

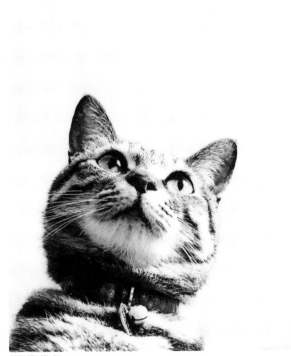

@ZEN_REN_SEN_SIN

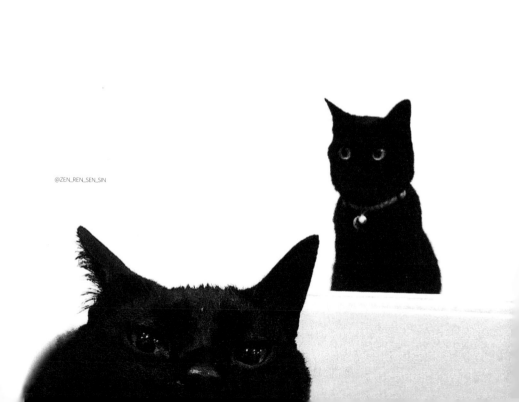
@ZEN_REN_SEN_SIN

"IF A CAT SPOKE, IT WOULD SAY THINGS LIKE 'HEY, I DON'T SEE THE PROBLEM HERE.'"

ROY BLOUNT JR

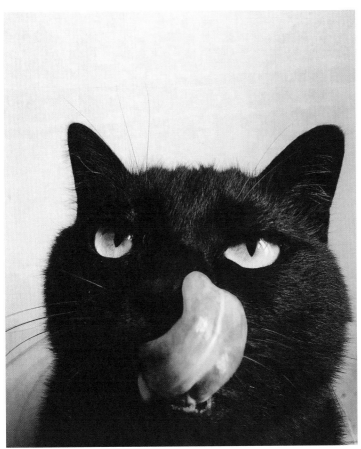

@ZEN_REN_SEN_SIN

@ZEN_REN_SEN_SIN

"NO, I NEVER THOUGHT I WOULD LIKE CATS"

KARL LAGERFELD

This book is
MARKED

MARKED is an initiative by Lannoo Publishers
www.markedbylannoo.com

Sign up for our MARKED newsletter with news about new and forthcoming
publications on art, interior design, food & travel, photography and fashion
as well as exclusive offers and events.

Photo Selection/Book Design: Irene Schampaert

Cover Image: @lyo.thecat

Also available:
Insta Grammar Cats
Insta Grammar City
Insta Grammar Nordic
Insta Grammar Dogs
Insta Grammar Green
Insta Grammar Graphic
Insta Grammar Unicorn
Insta Grammar Cars
Insta Grammar Love
Insta Grammar On the Road

If you have any questions or comments about the material in this book,
please do not hesitate to contact our editorial team: markedteam@lannoo.com

© Lannoo Publishers, Tielt, Belgium, 2020
D/2020/45/169 – NUR 652/653
ISBN: 9789401463485
www.lannoo.com

All rights reserved. No part of this publication may be reproduced or transmitted in
any form or by any means, electronic or mechanical, including photocopy, recording
or any other information storage and retrieval system, without prior permission in writing
from the publisher.

Every effort has been made to trace copyright holders. If, however, you feel that you have
inadvertently been overlooked, please contact the publishers.

#AREYOUMARKED